XXX

PORN FOR

women

XXX P♥RNO FOR women

Hotter, Hunkier, and More Helpful Around the House!

From the Cambridge Women's Pornography Cooperative

Photographs by Gretchen LeMaistre

CHRONICLE BOOKS

SAN FRANCISCO

A PORN FOR product.
PORN FOR is a trademark of Urgent Haircut Productions.

Library of Congress Cataloging-in-Publication Data:
XXX porn for women : hotter, hunkier, and more helpful
around the house! / from the Cambridge Women's
Pornography Cooperative ; photographs by Gretchen LeMaistre.
p. cm.
Includes bibliographical references and index.
ISBN: 978-0-8118-6438-1 (alk. paper)
1. Men--Humor. 2. Man-woman relationships--Humor.
I. LeMaistre, Gretchen. II. Title.

PN6231.M45X89 2008
817'.608035--dc22
2008004875

Manufactured in China
Designed by Tracy Sunrize Johnson

Photographer's Assistants: Kirk Crippens, Geoffrey Moore, Erich Morton
Stylist: Micah Bishop, Artist Untied
Assistant Stylist: Mariana Coolidge
Models: Lee Adkins, Henry Lee, Rodney Medeiros,
Damon Robertson, Elan Valldaraes, Kurt Yaeger

10 9 8 7 6 5 4 3 2 1

Chronicle Books LLC
680 Second Street
San Francisco, California 94107
www.chroniclebooks.com

Just ten months after we at the Cambridge Women's Pornography Cooperative (CWPC) released our first, best-selling book, *Porn for Women*, this entry appeared in the online Urban Dictionary:

Choreplay (chòr-‚plā) n (2007)
When a woman is turned on by the sight of her
husband/boyfriend/partner doing regular household
chores that she would normally be doing.

Example: "Last night, it was all about choreplay.
I was all 'OH YEAH, fold that laundry. Oh yes, just like that!
In half and, then in half again. OHHH'"

Are we changing the culture here, or what?

Since the first *Porn for Women* release, the CWPC has hardly been idle.
Our scientists have been back in our research laboratories, testing hotter,
steamier, and handier-around-the-house scenarios. Basically, we've been
continuing our life's work to find out **"what women really want."**

In this edition you'll see some new, highly rated choreplay. Plus, we've got some promising first results of our research into home renovation. Titillating stuff!

So curl up, flip through these pages, then share them with other men and women. And know that by spreading these revolutionary ideas, you're changing the world, one surprise gourmet meal, one unsolicited compliment, one perfectly folded towel at a time.

—*Cambridge Women's Pornography Cooperative*

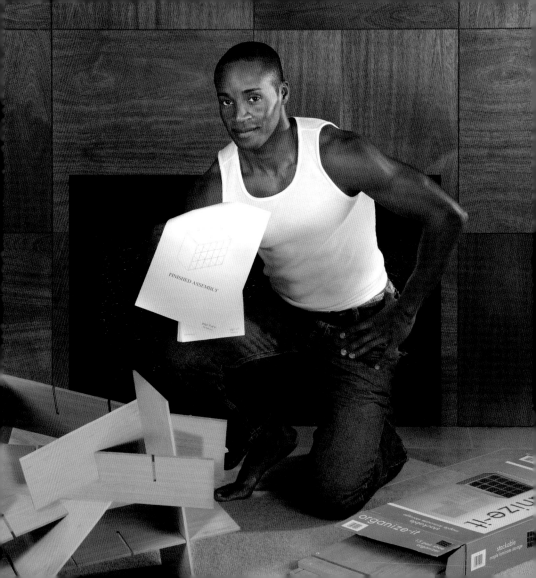

FINISHED ASSEMBLY

I'm not
going to start assembly
until I've read
all the instructions.

①.—②—③.

I just
don't get
this whole
supermodel
thing.

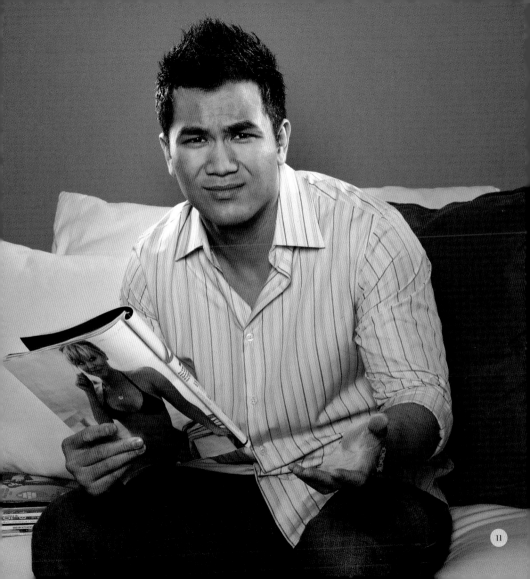

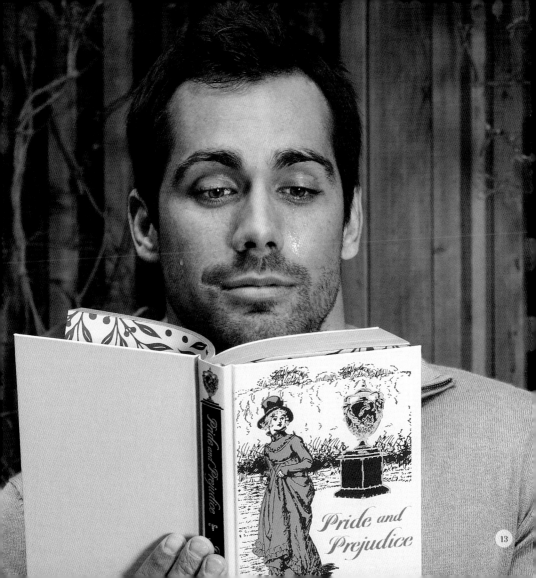

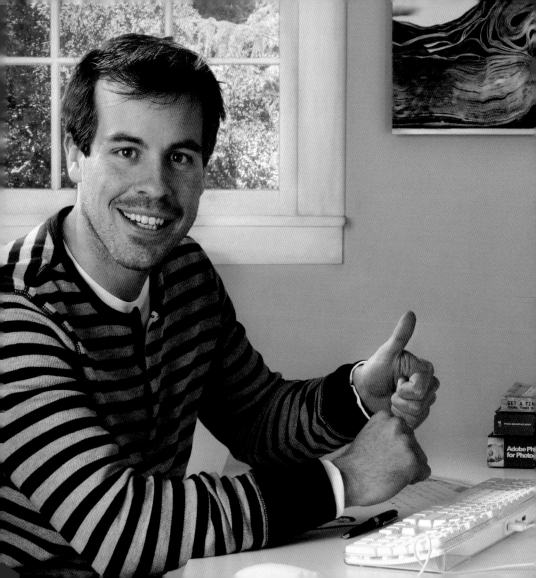

Bingo!

I found someone
who wants to trade
my **football** tickets
for the *ballet.*

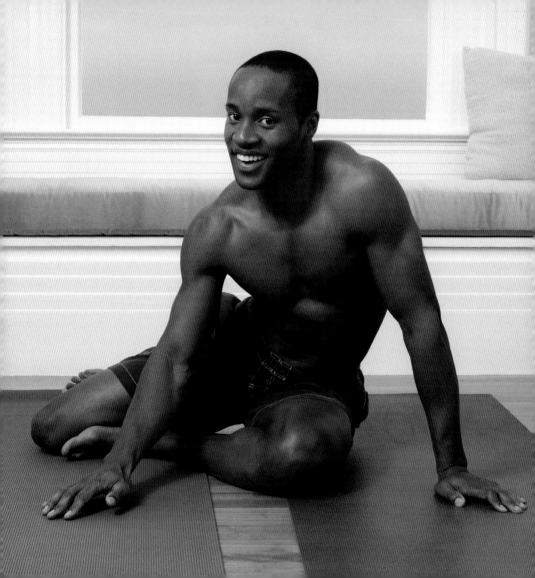

Happy **anniversary**!
I got us a year of
private
yoga instruction!

Damn!
I wish I had read this stuff
years ago!

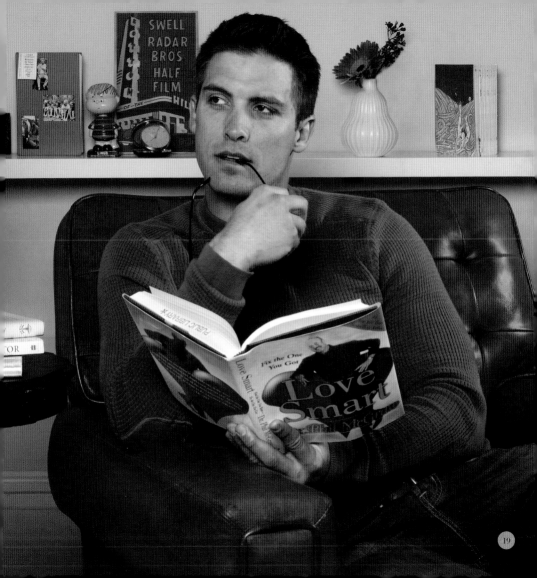

Antiquing makes me **hot**!

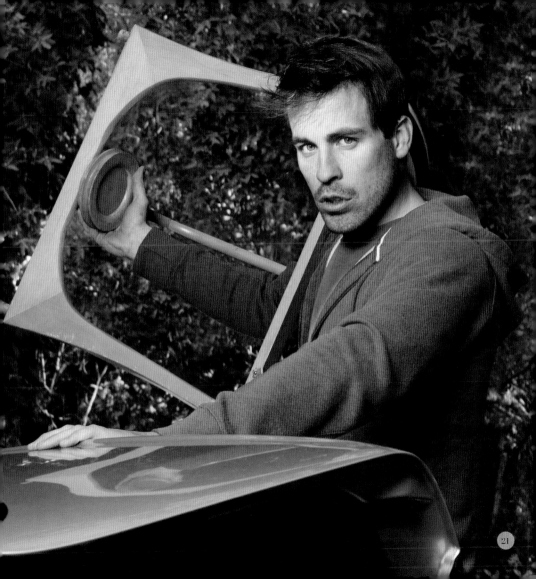

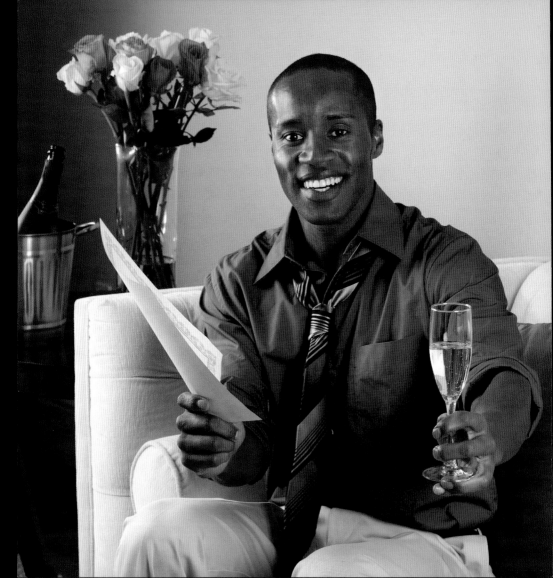

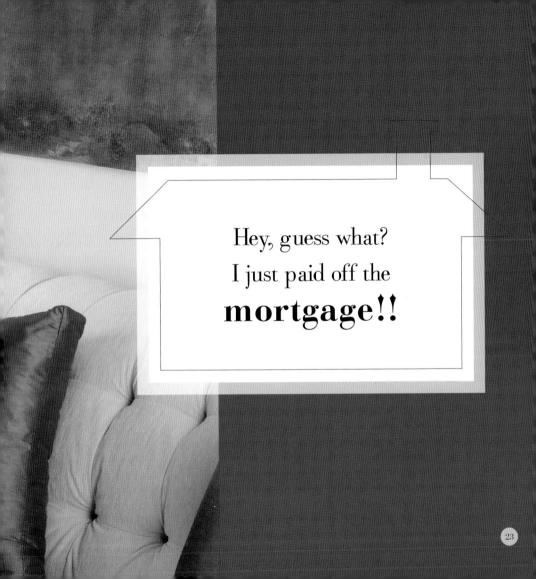

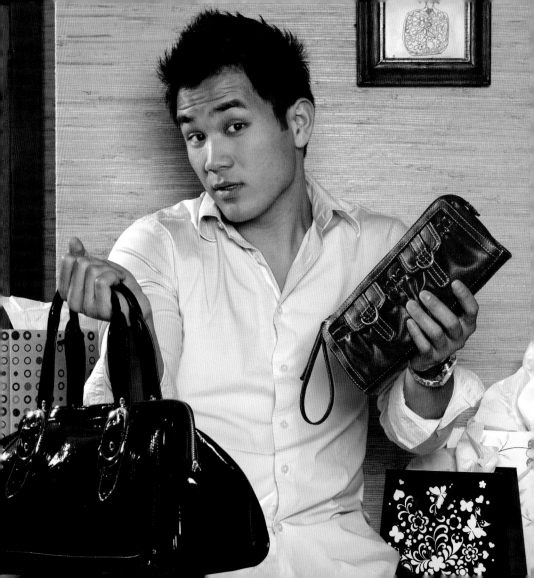

Keep **both** bags.

I don't care what they cost.

You **deserve** 'em!

I'm *so excited*

for your sister

to have her baby!

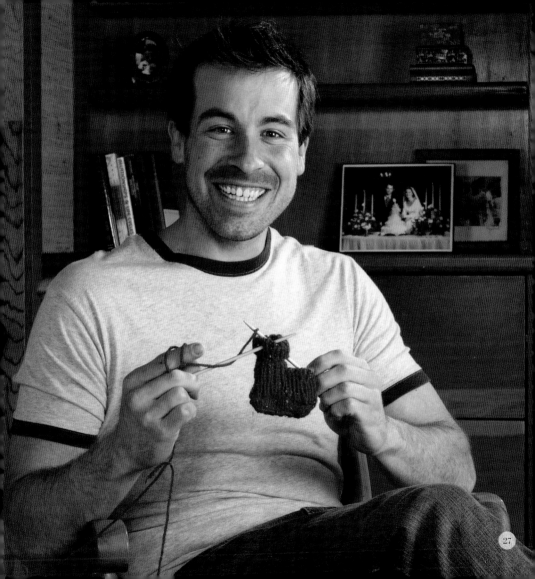

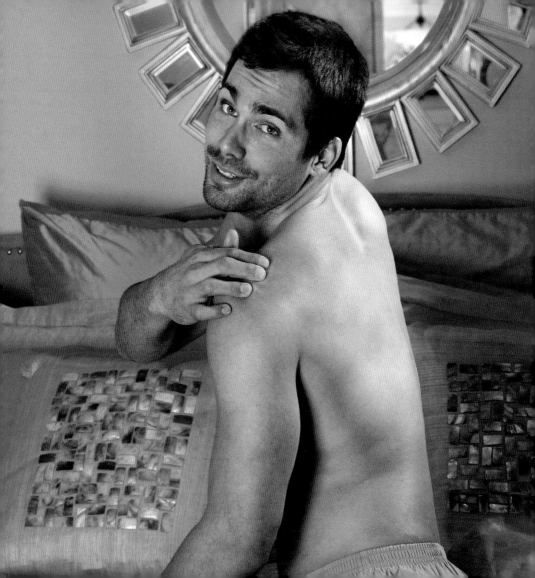

Did they miss a spot?

I'll go *wax it again* if you want me to.

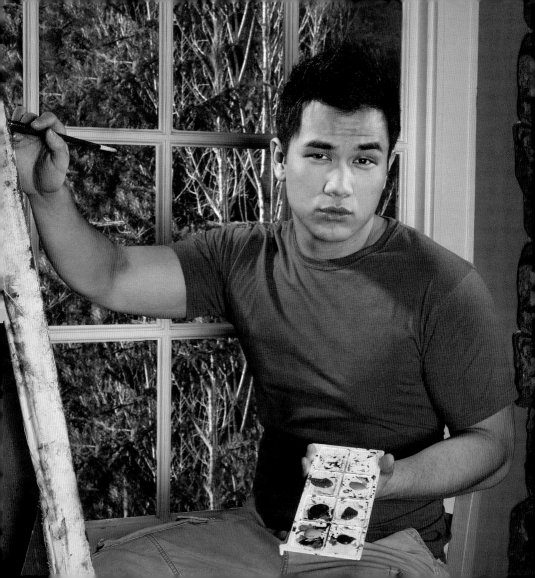

I

love

the way the

light

plays

with your hair.

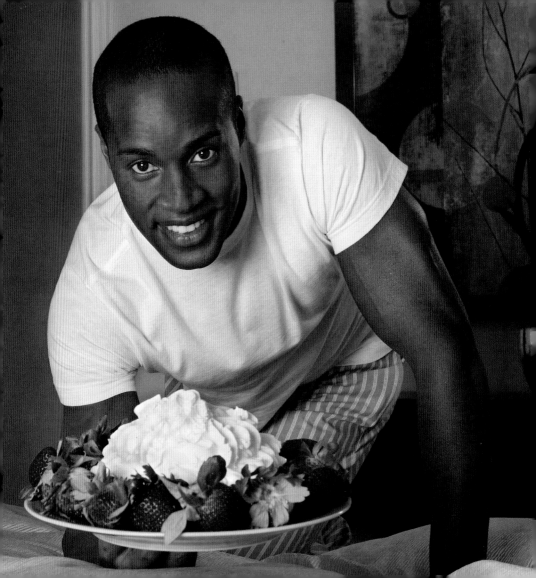

It's Tuesday.

That means

strawberries and cream

in bed.

You are **not** coloring your hair.
I've been waiting **years**
for that sexy silver to come in!

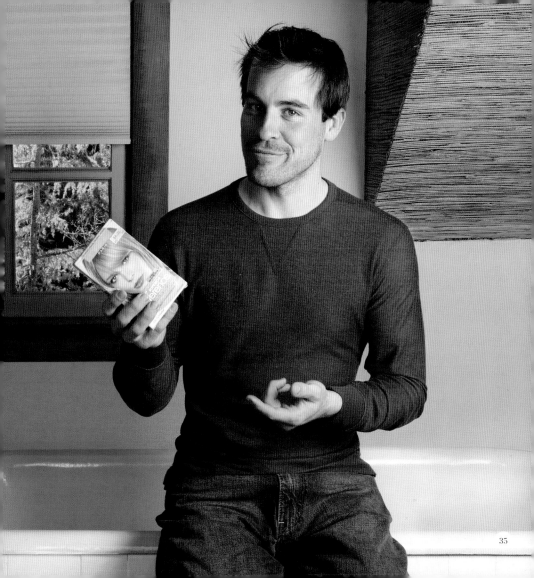

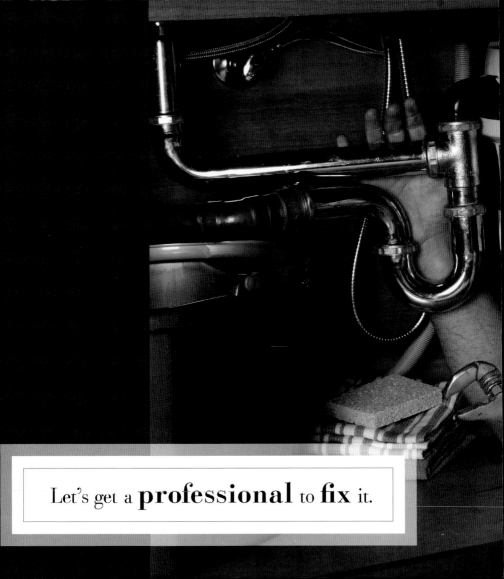

Let's get a **professional** to **fix** it.

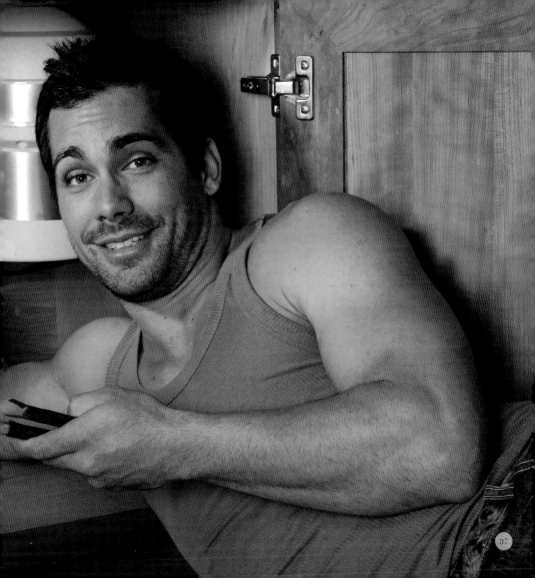

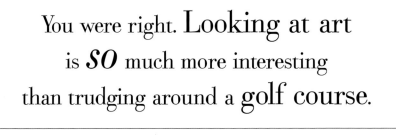

You were right. Looking at art
is *SO* much more interesting
than trudging around a golf course.

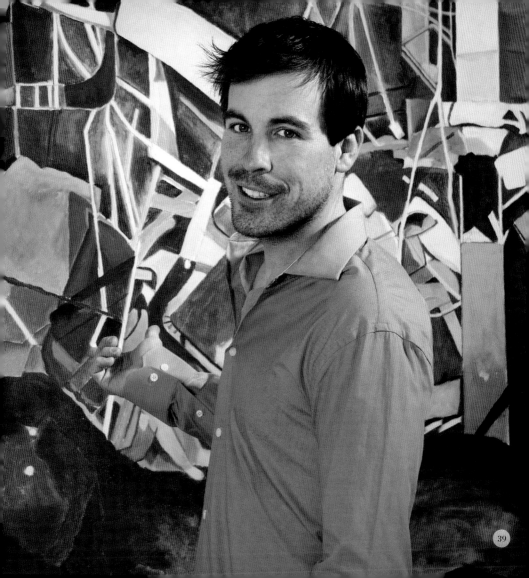

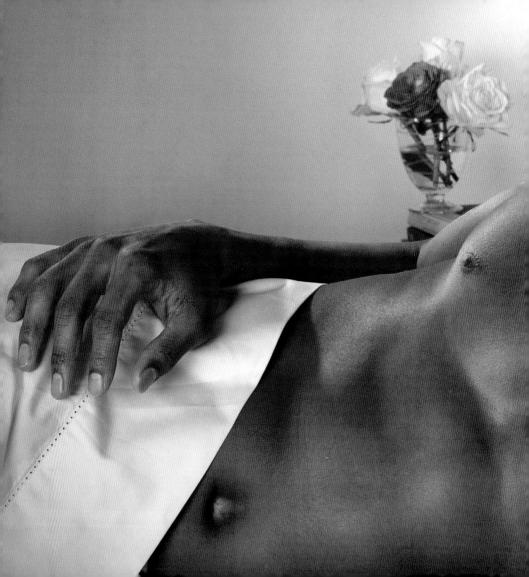

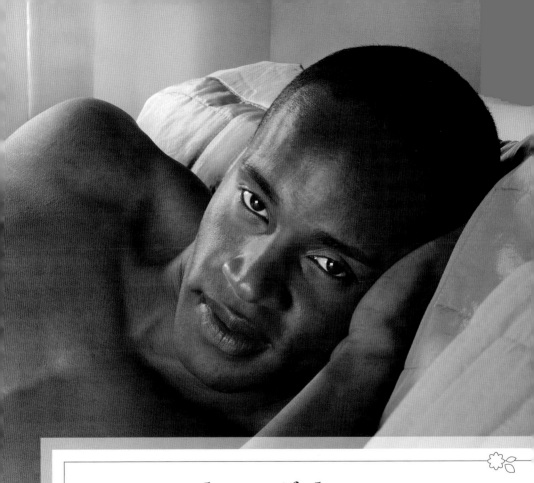

You get more *beautiful* every time I look at you.

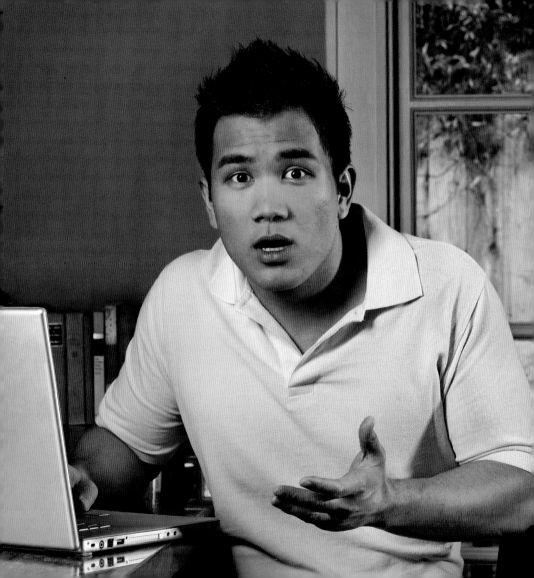

You're telling me there's

pornography

on the Internet?

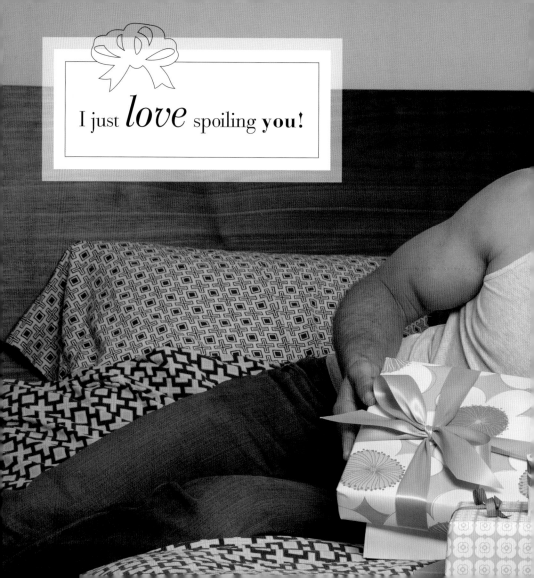

I just *love* spoiling **you!**

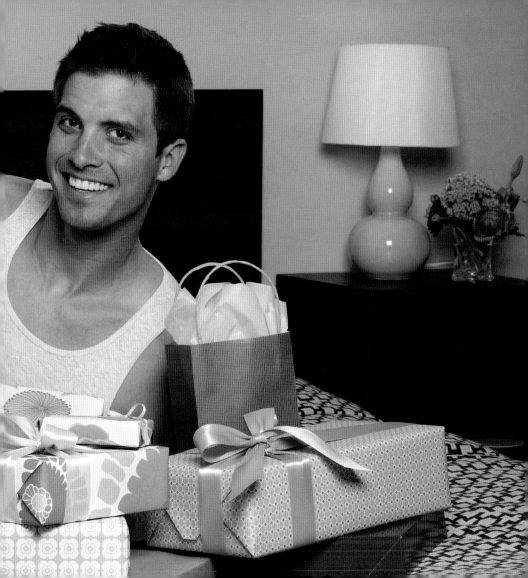

I thought I saw a streak.

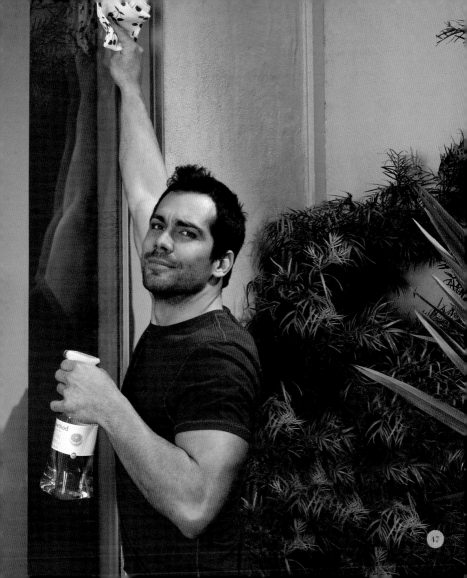

Invite your *whole* family for Thanksgiving.

I'm dying to take this baby for a spin!

I was **wrong.**

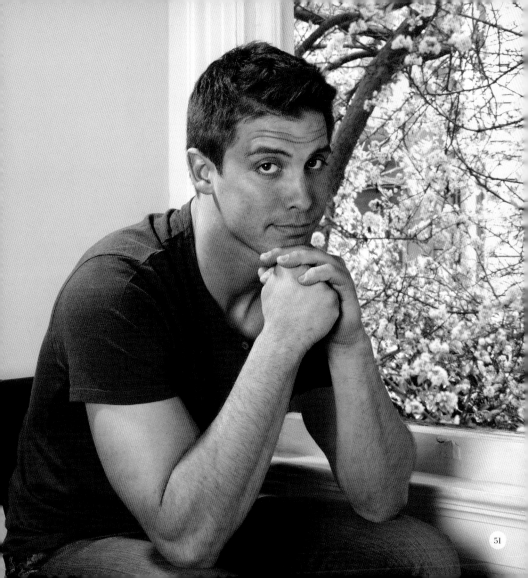

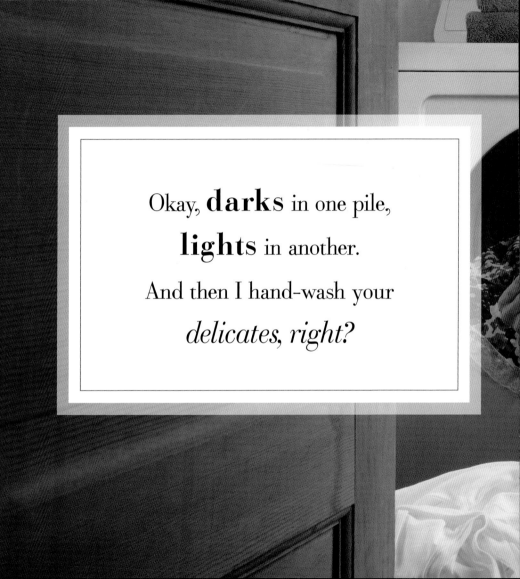

Okay, **darks** in one pile, **lights** in another. And then I hand-wash your *delicates, right?*

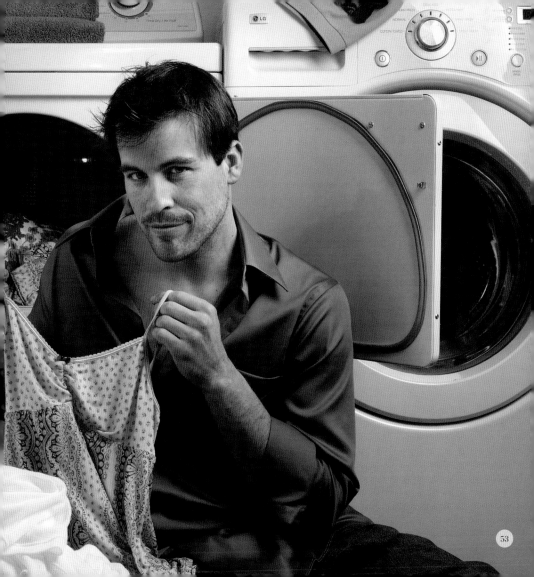

I'm perfecting my
homemade raviolis.
Any chance your
girlfriends
would come by tonight
for a tasting?

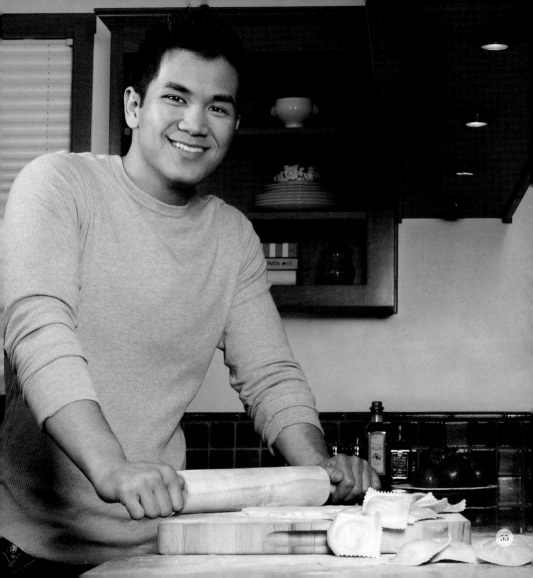

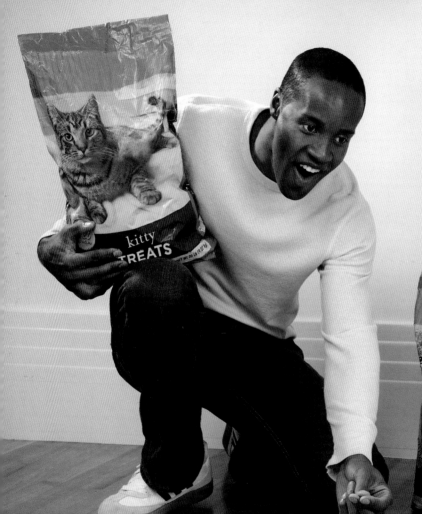

Fluffy is *so damn cute!*

I **love** this cat.

Hope I didn't miss anything

important

while I was on

paternity leave!

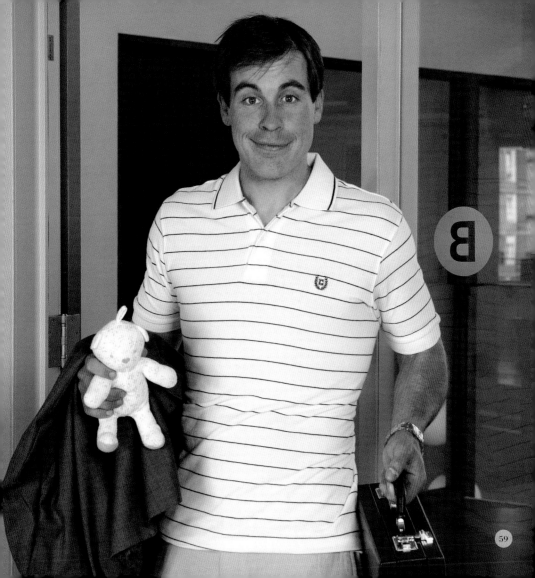

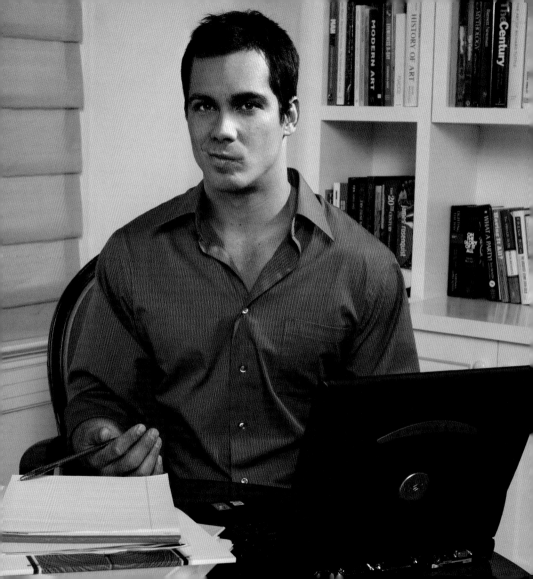

I know I have to work
twice as hard as a woman
just to get
equal recognition.

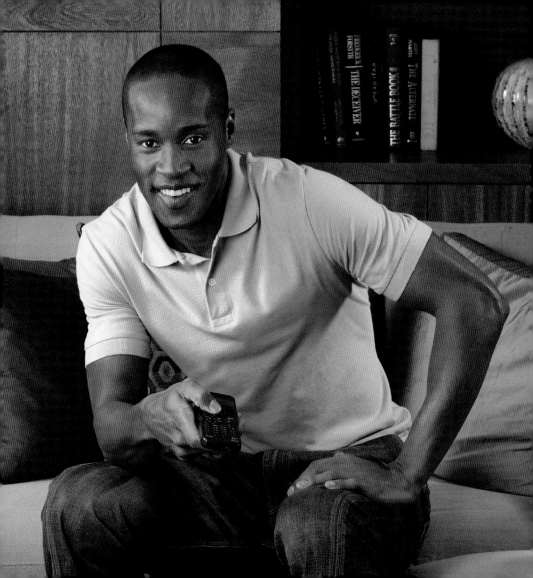

There.

I put **The Food Network** ahead of **ESPN** on the TIVO priorities.

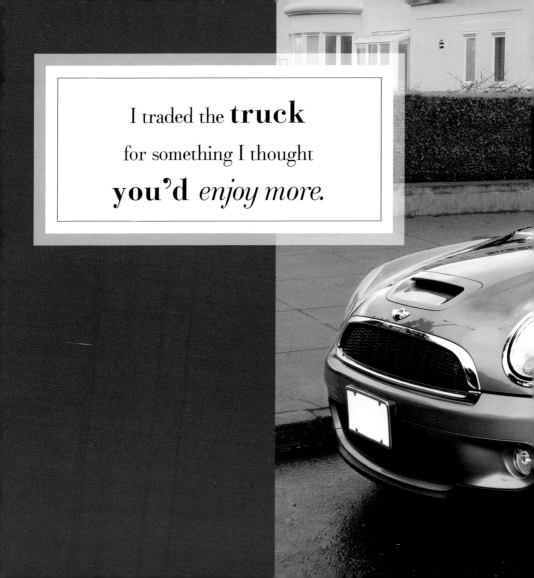

I traded the **truck**
for something I thought
you'd *enjoy more.*

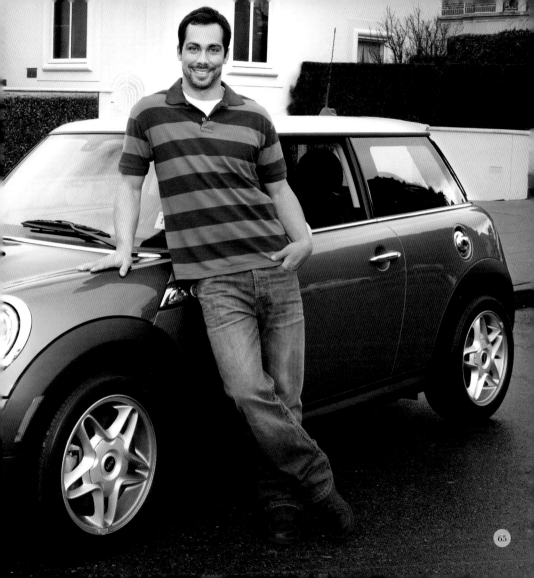

I thought I heard a **sniffle.**

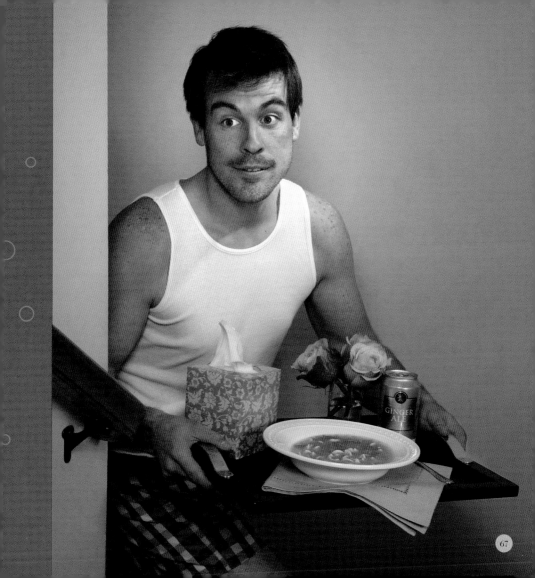

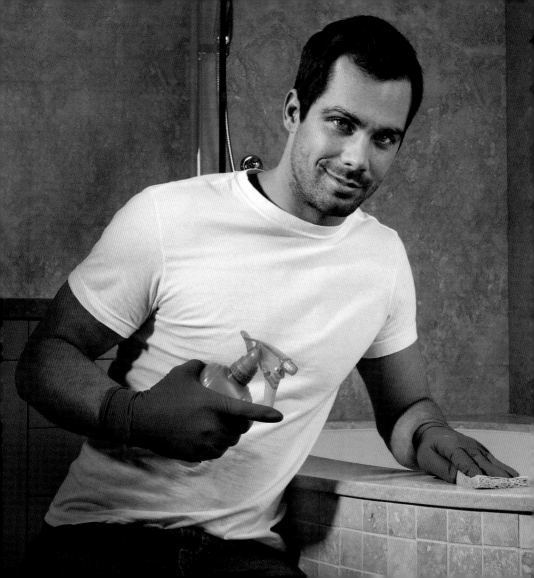

I'm gonna
make this bathroom
shine!

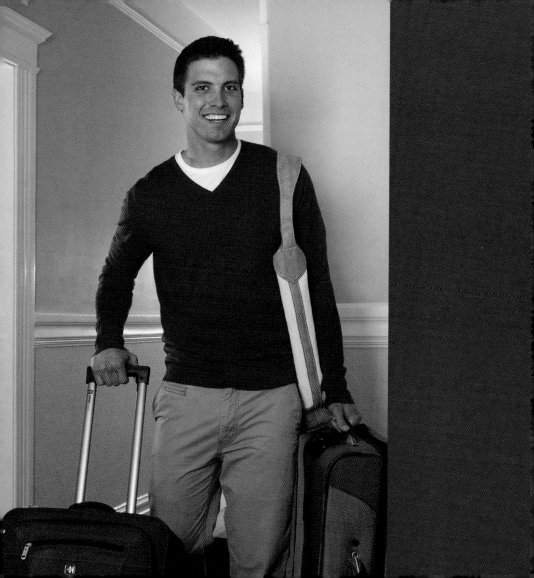

I know how you hate to fly

coach,

so I got us

fractional ownership

in a private jet.

Nah, **you** go out to dinner
with your friends.
I'll pick him up from his playdate.

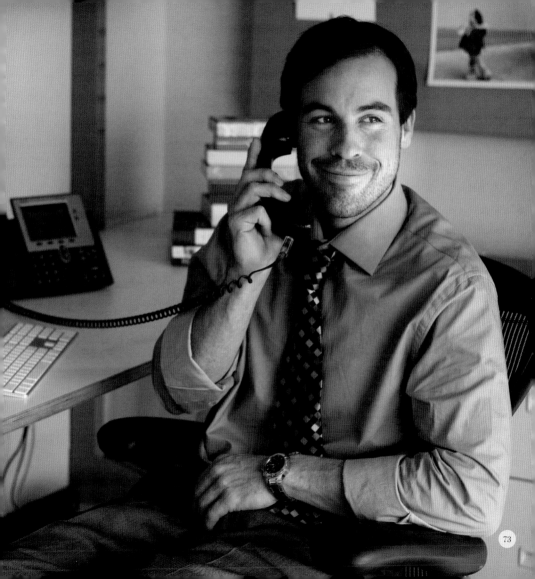

I rented a massage table—

tonight's about *your* needs.

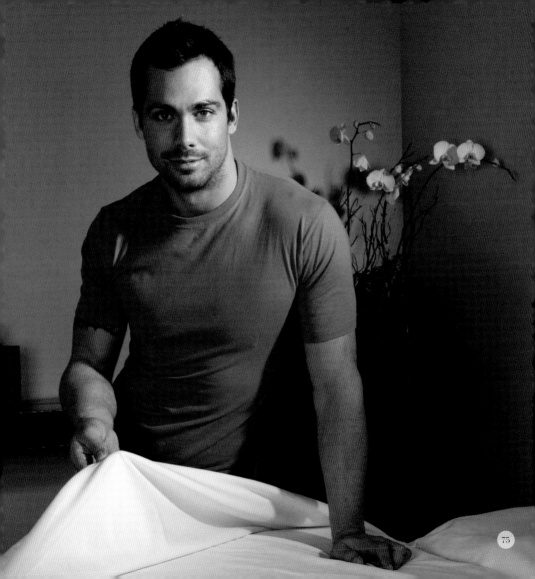

Days Without Peeing in the Shower:

287

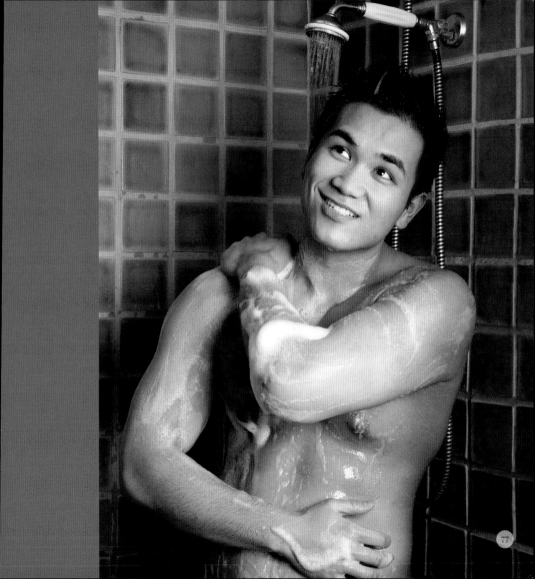

I wish **our** kitchen looked this good.

Let's *re-do* ours this year!

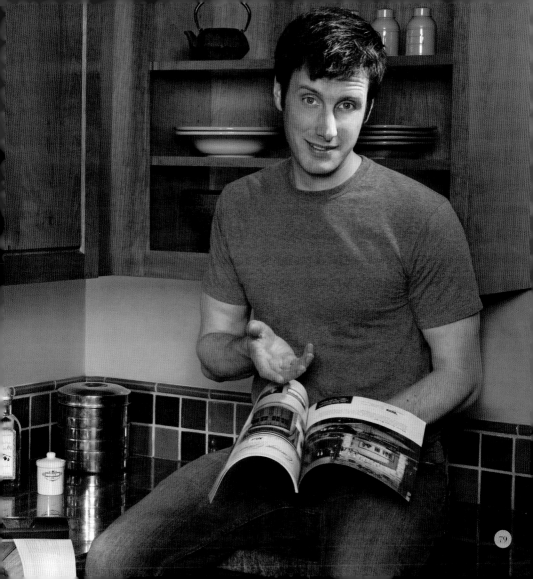

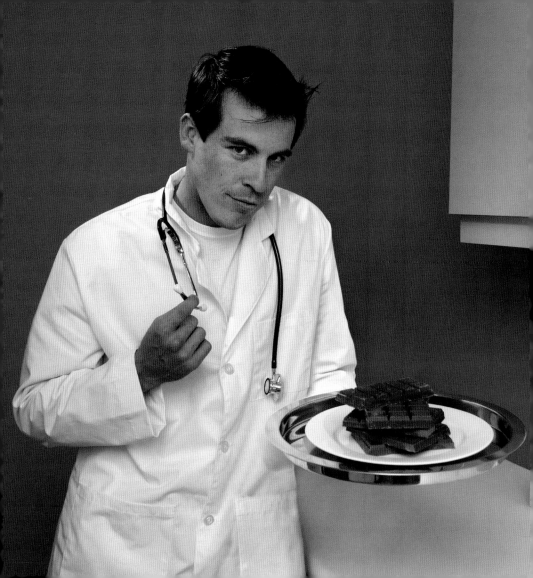

Now remember,
this is a **serious** medical condition.
It's important that you
keep up those calories,
and get plenty of
chocolate.

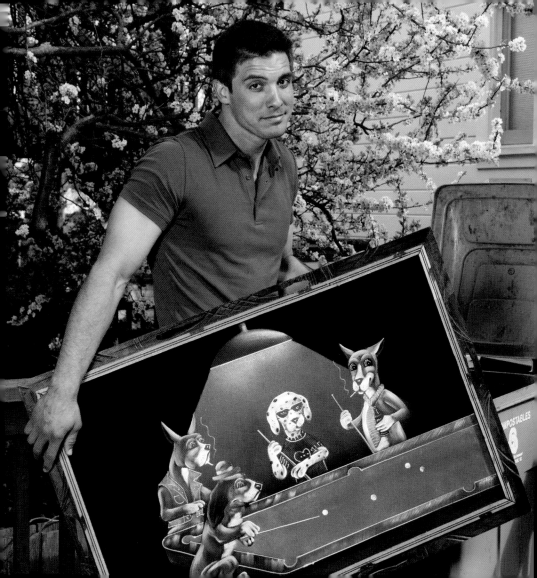

You're right,

it's time for my college stuff to **go.**

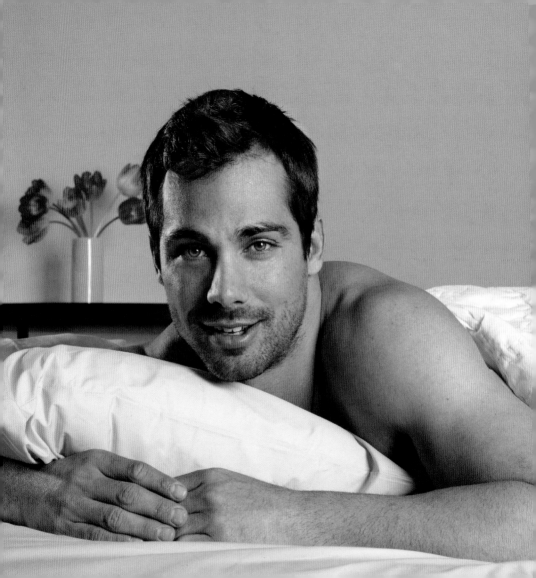

Nope.
I'm not done
'til **you're** done.

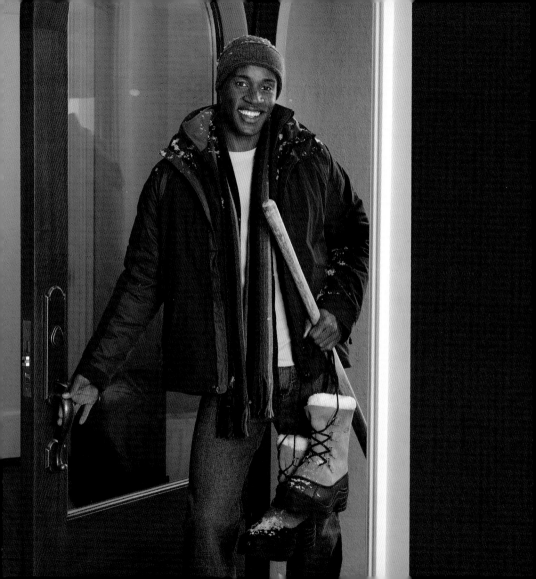

OK, the **driveway's shoveled,** and your car is all *cleaned off,* **warmed up,** and ready to go.

Pornometer Quiz

How comfortable should your guy be? Take this quiz to find out whether he's at risk for being dumped!

You call him at work and say that you need to talk.
- GREEN: You hear him tell his colleagues, "Sorry, guys. This is important. We'll continue our meeting later."
- YELLOW: He says, "Can we do it quickly? I'm kind of busy today."
- ORANGE: He tells his secretary to put you through to voice mail.
- RED: He puts you on speakerphone, so his buddies can hear, and then asks you about your bloating and irritability.

You make a romantic dinner, for no particular reason.
He comes home, sees the candlelit table, and says:
- GREEN: "I must be the luckiest guy in the world," and you see his eyes well up. "What did I ever do to deserve you?"
- YELLOW: "Did I forget our anniversary?"
- ORANGE: "Can we eat quickly? I don't want to be late for poker."
- RED: While looking down at his trousers, "Oh boy, looks like Mr. Johnson is finally going to get a little exercise tonight!"

You're out in public together and a particularly attractive woman walks by:
- GREEN: He doesn't even notice.
- YELLOW: You detect a brief, barely perceptible pause in the conversation, and he's embarrassed to see that you noticed it.
- ORANGE: He follows her with his eyes as she walks by, and then turns back to you and asks, "Now, what were we talking about?"
- RED: She says to him, "I thought you were going to call me, you bastard!"

Your anniversary is approaching, and you ask him if he remembers what important date is coming up next week:
- GREEN: He tells you not to worry about a thing, he's got restaurant reservations, show tickets, and he's made overnight plans for the kids with grandma.
- YELLOW: He gives you a dumb look for a few seconds, then smacks his forehead and gets to work on making plans.
- ORANGE: He gets it, but it takes him four guesses, including garbage day and toxic waste disposal day.
- RED: He says, "Yes! Charlize Theron's birthday!" And then starts making obscene grinding gestures with his hips.

You're driving together to another couple's house for dinner. You're lost.
- GREEN: He pulls into a gas station and asks you to excuse him while he goes in and asks for directions.
- YELLOW: He calls the couple, tells them you're running late, blames it on you for indecision over what to wear.
- ORANGE: Pulls into a Circuit City and drops $600 on a GPS navigation system.
- RED: He sees an adult video store and suddenly exclaims, "Ah! Now I know where we are!"

You're out to dinner with another couple. He turns and whispers something in your ear.

- GREEN: "You look amazing. I can't wait to get you home."
- YELLOW: "You know, you don't have to finish that whole dessert. It's OK to leave some."
- ORANGE: "Whoa there, baby. You're packing it in like a trash compactor."
- RED: As he's about to say something, the waitress walks by and says to him, "I thought you were going to call me, you bastard!"

You arrive at your parents' house for a weekend visit.

- GREEN: He gives your mom a big hug and tells her that he just doesn't see enough of her.
- YELLOW: He says a quick hello and heads to the TV to watch a game. Any game.
- ORANGE: While going through the family photo albums, he takes a little too much interest in pictures of your younger sister.
- RED: He gestures toward your mother's rear end and says, "I hope that's not a hereditary trait."

You're having a few girlfriends over for the evening.

- GREEN: He offers to cook and serve you all dinner.
- YELLOW: He asks what you're making.
- ORANGE: He asks who's coming, and when you mention an attractive friend, he suddenly decides to shower and shave.
- RED: He runs out to Home Depot and buys a six-person hot tub.

You meet your mate on a busy sidewalk.
- GREEN: He gives you a passionate kiss, oblivious to the impressed pedestrians who have to walk around you two.
- YELLOW: He smiles when he sees you, and gives you a hug.
- ORANGE: He gives you a high five.
- RED: It takes you three taps on the shoulder to distract him from chatting up the hot-dog vendor's daughter.

You suggest going to a romantic, foreign film with subtitles.
- GREEN: He says, "I'll bring some tissues for you, babe, in case it's a tearjerker."
- YELLOW: He says, "Will that girl from *Amélie* be in it?"
- ORANGE: He says, "Wake me up if there's some nudity."
- RED: You catch him replaying scenes from *The L Word* on his iPod.

You arrive home with a dramatic new haircut. He says:
- GREEN: "Wow! You look fabulous! Let me get some photos to e-mail to friends and family."
- YELLOW: "How much did that one cost?"
- ORANGE: "Wait. Something's different. Did you gain weight?"
- RED: "Don't worry, Honey! We'll get the guy who did that to you!"

MOSTLY GREEN: No risk. *Plan vacations* up to 18 months in advance.

MOSTLY YELLOW: Normal risk. **Exercise caution** when your younger sister is around.

MOSTLY ORANGE: *High risk.* Quietly consider which assets you'd like to end up with.

MOSTLY RED: Change Facebook profile back to single.

For best results, leave this book in plain view. Remember to leave the room to allow guests to discreetly pick it up and have a look (*PFW* neophytes are shy when presented with our titles). When you hear guffawing, it's safe to come back in the room and share the laugh.

You can support the work of the Cambridge Women's Pornography Cooperative by picking up a copy of the original *Porn for Women*, the equally steamy *Porn for New Moms*, or any of the CWPC's *Porn for Women* accessories, such as our calendars, journals, postcards, or fantasy coupons. See it all at www.wannasnuggle.com.

We're also interested in testing your fantasies. Got any you'd like to share with us? **Oh, sure you do!** Submit them via our Web site, and if they test well in our labs, you may see them in a future book!

y'all come back
real soon . . .